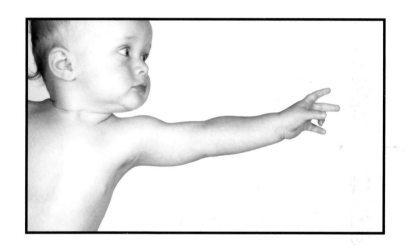

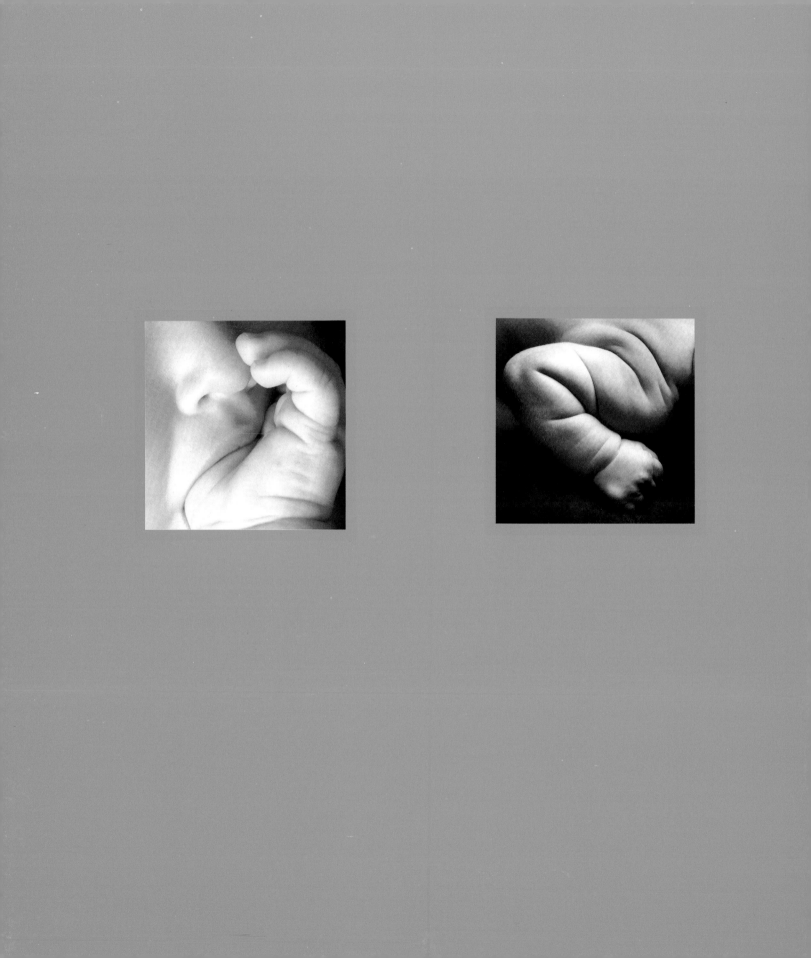

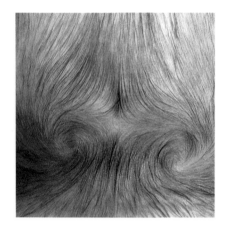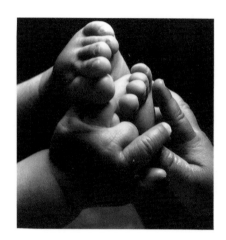

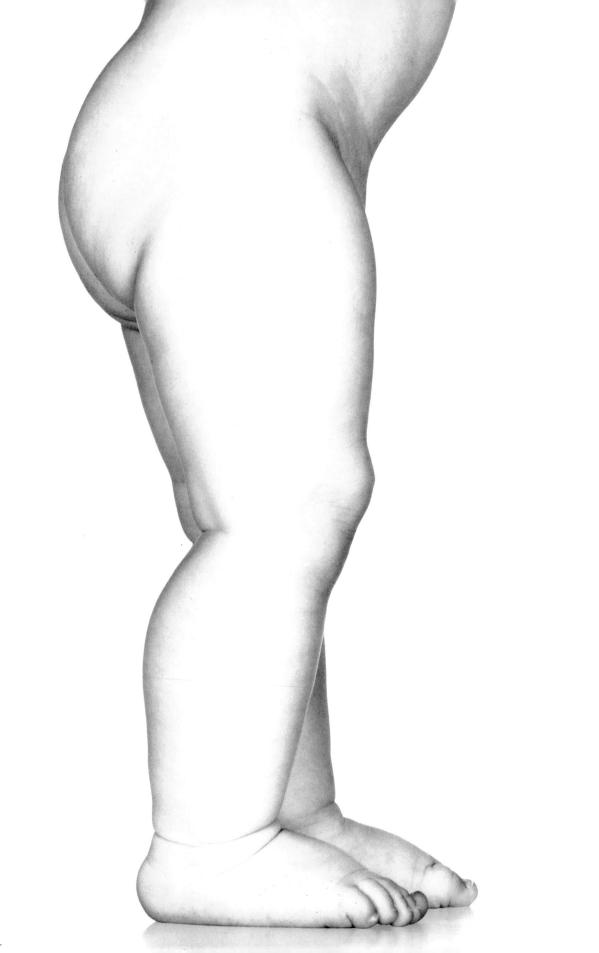

naked Babies

Nick Kelsh & Anna Quindlen

PENGUIN
STUDIO

PENGUIN STUDIO

Published by the Penguin Group

Penguin Books USA Inc., 375 Hudson Street,
New York, New York 10014, U.S.A.

Penguin Books Ltd, 27 Wrights Lane,
London W8 5TZ, England

Penguin Books Australia Ltd, Ringwood,
Victoria, Australia

Penguin Books Canada Ltd, 10 Alcorn Avenue,
Toronto, Ontario, Canada M4V 3B2

Penguin Books (N.Z.) Ltd, 182–190 Wairau Road,
Auckland 10, New Zealand

Penguin Books Ltd, Registered Offices:
Harmondsworth, Middlesex, England

First published in 1996 by Penguin Studio,
an imprint of Penguin Books USA Inc.

3 5 7 9 10 8 6 4 2

Photographs copyright © Nick Kelsh, 1996
Text copyright © Anna Quindlen, 1996
All rights reserved

CIP data available

ISBN 0–670–86880–9

Printed in Japan
Set in Centaur MT
Designed by Lisa Winward & Lia Calhoun
at Kelsh Wilson *design inc*.

For my parents, Joyce and Bud. Five babies and love left over.

—*Nick Kelsh*

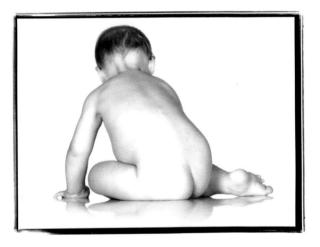

For Betty Krovatin, mother-in-law and in love.

—*Anna Quindlen*

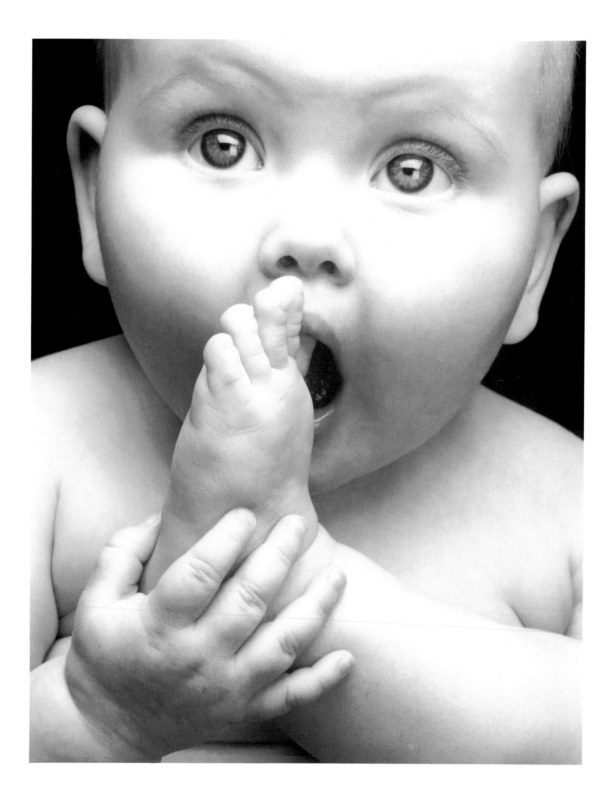

Naked Babies

One cold day at the bus stop my eldest child, then five years old, turned toward the behemoth of my belly and squinted his onyx eyes. "Mommy," he said, "is the baby wearing any clothes in there?" ⸱ It was a comical notion, the idea of his in-utero sibling—a sister, it later turned out—floating in the amniotic fluid in a sweater and booties, mittens and a hat. No, I said, the baby was naked, naked as he himself had once been, dragged forth by forceps after a half-day labor.

Naked as his brother, tumbling onto the table in a tiny birthing room with a

Mary Cassatt looking down from the wall and one window framing the sun

rising over Greenwich Village. I did not add what I'd learned by looking at

the two of them, smelling and stroking their sweet crepe-de-chine skin,

admiring the swell of their bellies and the dimpling of their tiny butts—that

any human being with the slightest bit of aesthetic intuition understands

that babies are meant to be naked, as surely as

they are meant to be nurtured and loved. ❧ Of

necessity we do otherwise, because of climate and the great societal frown

that seems to accompany even the most innocent nudity. We put froufrous

on the little bottoms, cover the little feet with shoes and socks, pull on

t-shirts and sweaters as the babies, wiser in their ignorance and their

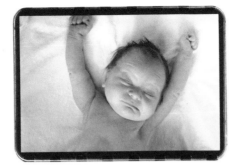

intuition than we, wriggle and grimace and wail away. Closer to nature, they

understand that when clothed they are in an unnatural state. This is why a

baby zipped into a snowsuit often has the look upon her face we see adults

assuming only in mug shots. ❧ I don't have babies anymore, although it

seemed for a time that I had nothing but: no life, no time, nothing but full

diapers and drool on the shoulder of my sweater. And I've gained a freedom,

and a maturity of dinner table discourse, that I scarcely would have thought

possible in the years of nonstop breast-feeding and double strollers. But I've

lost something, too, and every time I see a baby, particularly certain parts of

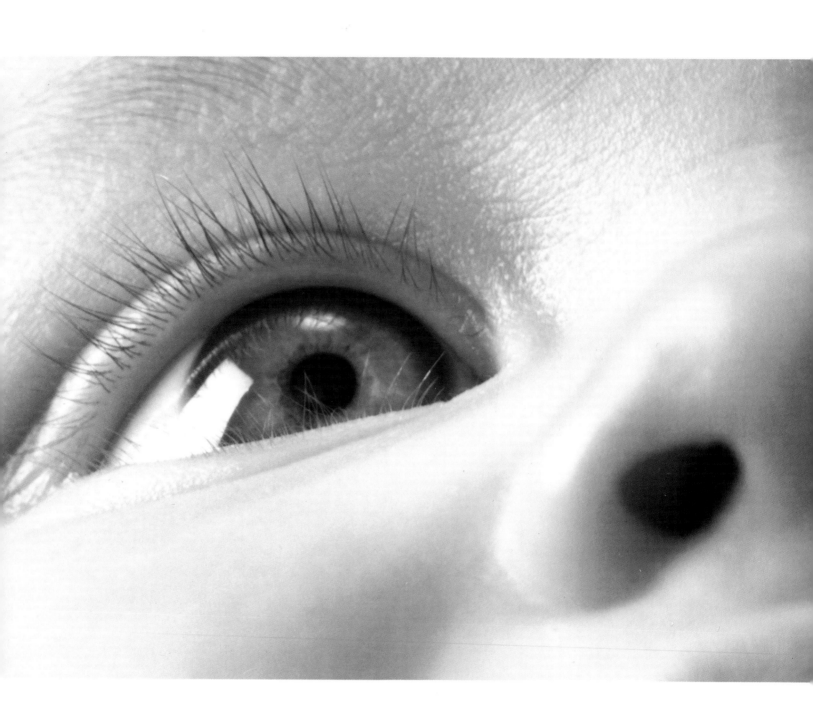

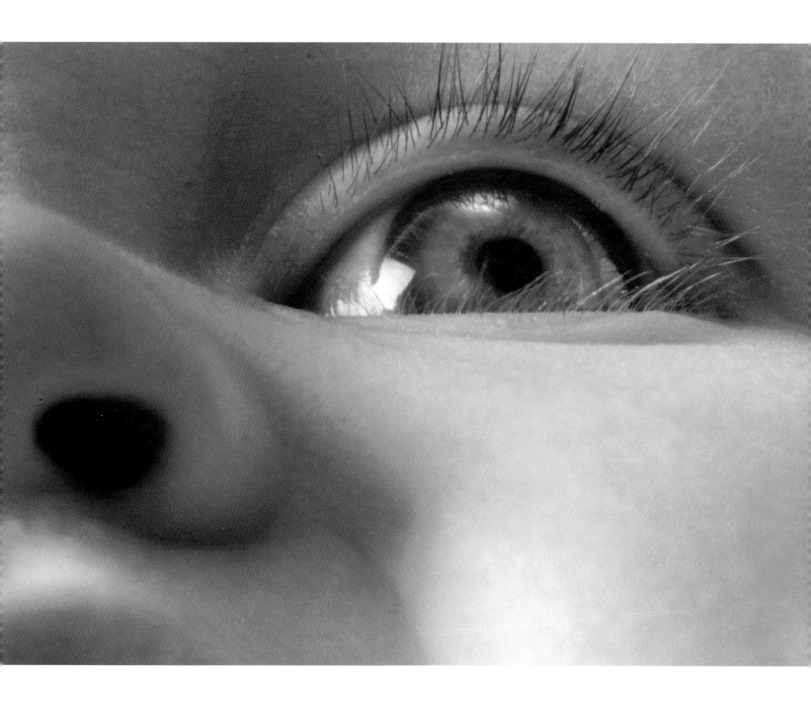

one—triple-roll thighs, the back of a neck feathered with fairy hair, knuckles

like bread rising—I am reminded of that loss. Until recently I thought of

this phenomenon as baby fever and wondered how I'd possibly survive one

more child, and how I'd survive not having one more. Now I think it has

more to do with a state of being that babies exemplify, and for which we all

yearn: paradise before the serpent, life without elastic marks, nature free of

the picket fence of civilization. That is why, with few exceptions, adults

in the presence of a naked baby reach out their

hands, as though to warm themselves at the

fire of perfection. As Tom, the orphaned chimney sweep of the

children's classic *The Water Babies*, muses when he has been transformed,

"He felt how comfortable it was to have nothing on him but himself."

§ Perhaps the babies apprehend this somehow, too, because except for

when they are very tiny, fresh from the amniotic hush and when the pull

of battling sensations jangles them almost to the point of hysteria, a naked

baby is a happy baby. Nothing binds, pulls, pinches, straitens. And the

most amazing voyage of discovery can take place by inches, a million times

more mesmerizing than a crib mobile or a busy box: the sensation of feeling

your own hand, toe, penis, or nose, and being taken by complete surprise

at finding that the touch evokes a feeling within as well as without.

What, they seem to say with their liquid eyes as they fondle their own feet, is going on here?

§ A baby is the essential virgin. That lovely word, freed from its sexual and

religious baggage, means merely this: "not altered by human activity, being

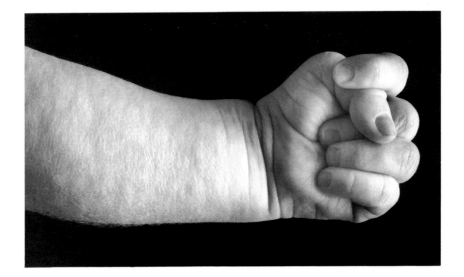

used for the first time." We see this in all the things a baby discovers and studies that we adults, dulled by experience, never notice, or never notice until a baby comes along. I remember these things from the babyhood of my own three: the way the eldest would lie on the floor transfixed by the butter-yellow light spilling through a bedroom window onto a wall and floor; the way the second would work his arms and legs in a kind of prone jumping jack, then stop with furrowed brow to consider what had just taken place before he began again; how the youngest would twine her fingers in her thick black hair and pull hard, then let out a scream of disbelief and rage. The way all three would suck their thumbs with eyes at half-mast, hold on for dear life to their own feet, explore earlobes, nostrils, and even the occasional eye socket with fingers hungry to discover the meaning of life—or, at

least, any available orifice. ❧ And truly, the meaning of life is in them, although not in a way that they can appreciate or even see. When our children were little I would, as I described it to myself, unwrap the package at any opportunity to look at the pink fullness of each of them, their perfect bodies. I used to think that I did this as an act of hubris, that basically I wanted to look at my own creation, the best and most effortless of all the things I, a writer, had managed to cobble together from nothing. But what I saw, when my babies were naked, was something more. It was myself. Not the self that gave one her thick brown hair or another his brawny little body, the self that shows itself in mannerism, accent, even personality. It was the self that I was before cold and heat, falls and accidents, loss and disaster. A naked baby is humanity stripped down to its essence, perhaps to its soul, and Lord,

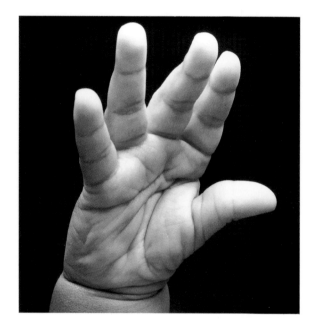

is it good. A naked baby is like a field after a snowfall, before anyone has

walked across, before the thaw or the plows. When you read Genesis,

imagine Adam and Eve before the snake

showed up, this is what babies are like, with

unscarred skin and hair like duck down, fine

as sunshine. ❧ This magical quality of paradise regained is not just in

the way a baby looks, although there is plenty in the strictly visual to feed our

hunger for it, a hunger evident in so many books, and songs, and films. It's

why we are riveted by baby feet, which so evidently have never been walked

on, on which the toes curl in their natural, inevitable commas, without the

constraint of shoes. Or baby knees and elbows, not knobby or roughened but

round and dimpled. The soft slope of baby shoulders, the perfect apple

cheeks, both fore and aft. The perfect skin that smells like spring just before

it falls over into ranker summer. The hair that has been neither cut nor

colored, curled nor tortured into place. The slopes and valleys and peaks of

thighs and belly and navel and genitalia, the topography of the human body

before it's learned 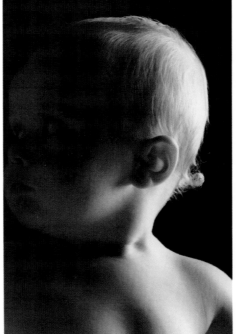 pain or shame or

self-consciousness. That last, above all.

Babies have not yet learned to act

through a scrim. Looking at them,

you see people as they would be were

the world perfect. But you also see

people before they have learned to

perform and conform. Watch a baby of a certain age who has been removed

from his mother's arms. No stiff upper lip, no determination to make the

best of a bad situation, no little man posturing. The face moves in freeze

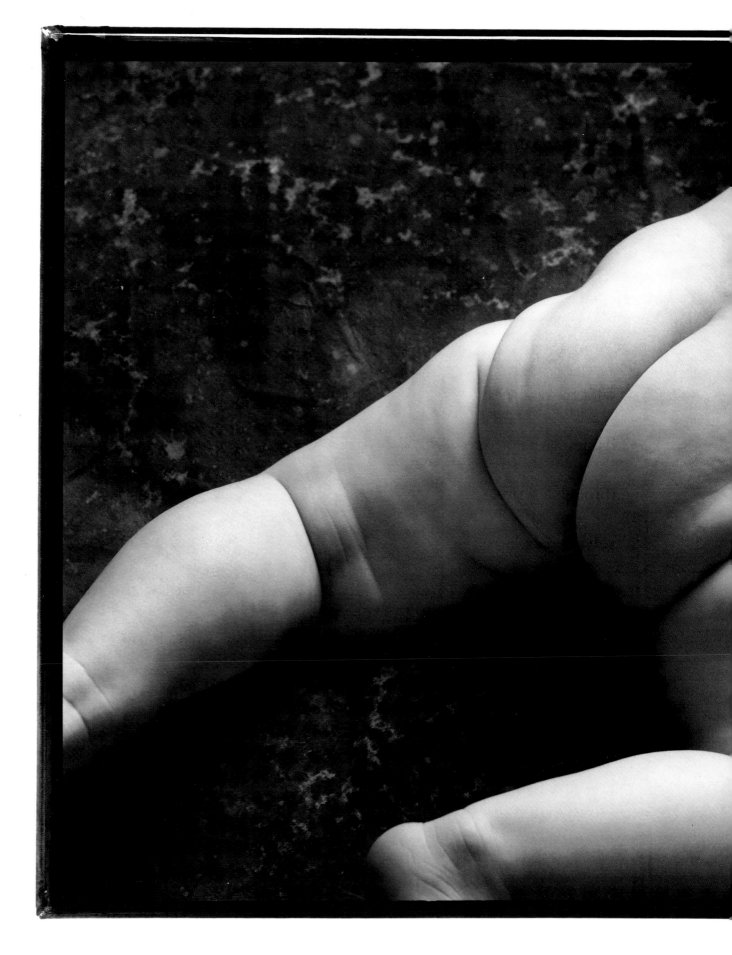

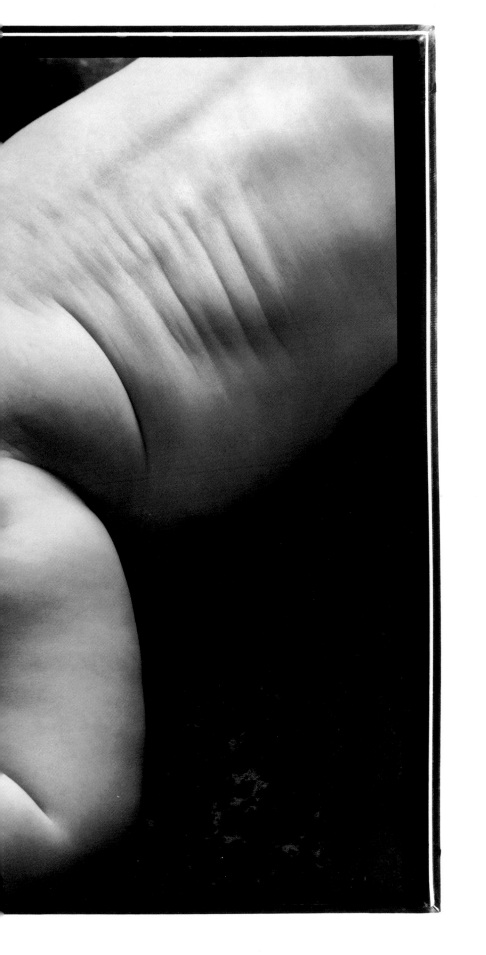

frames from the stillness of shock to the wide eyes of amazement and then

creases and crumples into all-out bereavement. This is emotion before the

emoter learned, in one sad fashion or another, to stuff it deep inside. When,

some years ago, there 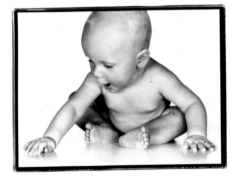 was a vogue for

regression therapies that included reliving

birth and curling up in a fetal position,

most of us scoffed. But perhaps more

than a few of us thought, at least for a moment looking at our babies,

that here was a pure soul, the personality's living room

before it became cluttered with the furniture

of parental projection and societal pressures. ❧ Surely babies,

particularly naked babies, in all their pink, white, beige, brown, and

parchment-yellow glory, are the antidote to pain, and more than that, to

death itself. This might seem a rather obvious point, the debut of life being

in opposition to the waning and the ending of it. But the point is physical as

well as metaphysical. I've watched people die, up close and by inches, and as

you might imagine, or know from experience, it is a terrible thing to watch.

But one of the things that take you by surprise about it is the literal daily

diminishment, the sight of a person whittled away to no more than skin

stretched painfully over skeleton, until at last it seems he might simply fade

out, disappear. ❧ The burgeoning baby is the exact opposite of this: each

day she seems to swell, her cheeks to puff, her belly to balloon. It is as

though life is filling her up, even though we know in fact that it is breast

milk and oatmeal. This is one of the reasons why it is so fearsome to look

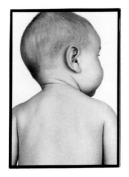

at premature babies, because their wizened limbs and tiny skulls look too

much like age and not enough like nativity. One of the funniest, most intu-

itively knowing photographs I have ever seen of an adult with a baby was of

the actor Robin Williams with his infant son. He was holding the child aloft,

the small foot in his mouth, his cheeks puffed out, as though he were inflat-

ing him. That is how babies come to look, at their ripest, somewhere between

four and nine months, like balloons full to the brim with promise. It is why

most people seem drawn to them like ants to a pool of spilled syrup, because

of an unconscious feeling that they can bask for a moment in what we love

and know we will lose: pure, unadulterated life. And maybe even something

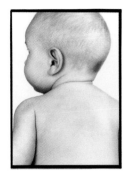

before, or after. I remember my amazement when I first took our eight-month-old daughter into the pool and watched her drop like a submarine beneath the surface, her lips pursed, her eyes open, two black stones and a circle of rose quartz beneath the glistening sheen of blue. She surfaced and went down again, surfaced and went down, and I saw in her sure movements a kind of prememory of a life lived underwater, her lungs useless, her hair waving wet around her melon head. I wished that I could crawl inside her to know what she was thinking and feeling as she went up and down, up and down, as she struggled and screamed when she was taken from the clear water, dried, diapered, clothed, forced back to land, to earth. ❧ There is

a power to them, but a great encompassing weakness too, for if babies

epitomize self before we screw it up, they also are self without protection,

vulnerable from their thin skins to their big heads so wobbly on the fragile

stem of their necks. New parents find a variety of ways to pay homage to

this, from obsessive overdressing to cribside monitors. Some of us have used

the simple expedient of hovering over the crib throughout the night, looking

in the moonlight for the faint rise and fall of the chest, the calisthenics of

respiration. They are the strangest combination,
these little larvae, of toughness and fragility. One

afternoon I watched in horror as, in slow motion, one of mine rolled off our

bed—thunk! scream!—onto the hard wooden floor. Without hesitation I

went straight to the emergency room, there to have him poked and prodded

into a frenzied crying jag that implied at the very least a broken collarbone, in all probability a fractured skull. "When was the last time you fed him?" said a kindly nurse. He looked such a candidate for dislocation or sudden death, when he was only famished. ❧ Who was it coined that old saw about God making them so cute so we will not kill them? It has particular resonance at 4 a.m., the deepest darkest hour of the day, when no walking, no rocking, no feeding, no singing will bridge the membrane between waking and sleep. It is the perfection, the sheer beauty of their baby bodies that make us recoil from those who would hurt or hit or maim them; the impossibly soft back of the neck, the tiny barrel of the rib cage, the turned-in toes, seem almost to cry aloud, "Take care of me. Protect me from all harm."

ꝶ It does not last forever, this time between caterpillar and butterfly. For

those of us for whom it is in the past, it seems to have lasted minutes,

moments, but moments that are indelible. I only need to breathe in deep

the powdery sweet 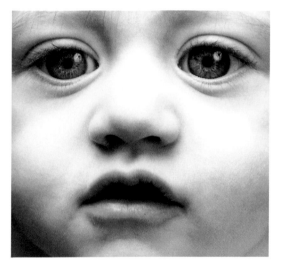 smell of baby

hair to bring it all back to me

instantly, the feeling of one

of them slung insensate across

my shoulder, gnawing on my

knuckle in an orgy of teething, bouncing on a small butt atop the table of

my knees. And the tiny ears. And the toothless gums. And the crease from

armpit to midchest. All of it, all of it. Then, suddenly, gone. In turn, our

three babies had their picture taken by a professional photographer, a lovely

older man who had seen generation upon generation of babies come and go

and grow. Each of our children was toted off to his studio just before turn-

ing a year old, and each time, as I requested some shots in the nude, he would

say, "You brought 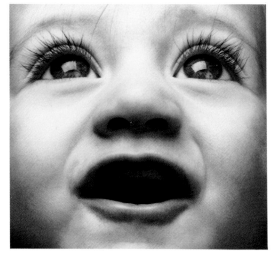 them in just in

time." ❧ It is only now that I truly

understand what he was saying, as

I look at those shots of the still

pink, still silky skin. In *The Water*

Babies the boy Tom is swimming naked down a stream: "He only enjoyed it,"

the story says, "he did not know it, or think about it." But looking at those

pictures of my naked babies now, I can see, in the narrowing of their still

chubby cheeks, the straightening of their bowed legs, how each was floating

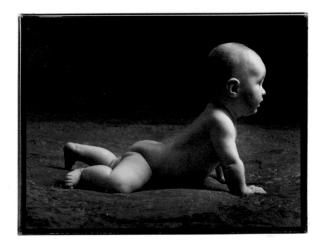

down a stream and ready to tumble over an unseen waterfall at its end, into life, out of baby-hood, into knowledge, into a time when they would need their clothes, a time, finally, when they would clutch them to themselves. Sometimes I think my last baby knew this; just before her second birthday she went through a period in which I would go upstairs to rearrange her blanket, check the door, adjust the light, in the empty oversight rituals of simmering parental protectionism, and find her Doctor Dentons in a woolly pile on the floor with a diaper splayed atop them, and my last baby naked beneath her comforter. Each night I tried a different tack: reason, ire, threats. I said she would catch cold, wet the bed,

wake in the night unhappy and wake me too. But for several weeks she

continued to strip naked and lie down to sleep. Who could blame her?

Perhaps she was saying good-bye in some secret intuitive way to her

sweetest self. § A naked baby is a kind of androgynous thing, sensual as

anything but sexual not at all. A boy, a girl—well, they are something else

unclothed, once knowledge begins. Still perfect, still beautiful, but some-

how reminiscent, in their overalls and shirts, of Adam and Eve after Eden,

or at least after they learned that words could hurt, that others might be

mean, that life was glorious and also sometimes painful. § The rest of the

journey, of course, is an attempt to learn that, and to learn to live with it,

to float down that stream knowing, thinking, but buoyant nonetheless.

Only now and then do we glimpse a time when we were better than that,

when the tang and the tingle of the water was sensation enough to make us

shudder, flail, and trustingly submerge, when the sunshine was a miracle,

the breeze a marvel, and we a marvel ourselves. Naked and new,

nascent and perfect. The sight of their bodies

calls out to something deep inside us, dredges up

regrets but glory too, and a taste of the perfection that slips away, minute by

minute, as we grow and learn and fall and falter and fail, cover ourselves with

coats against the cold of everyday life.

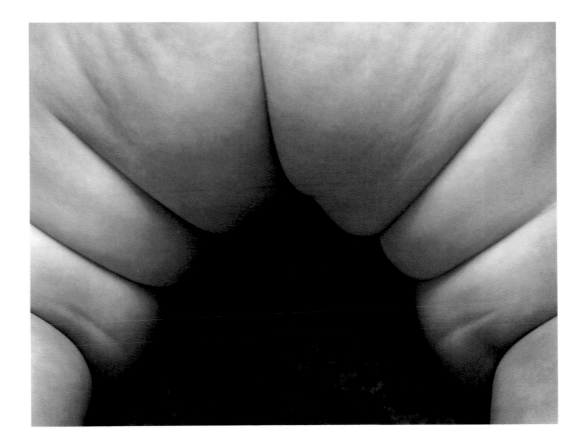

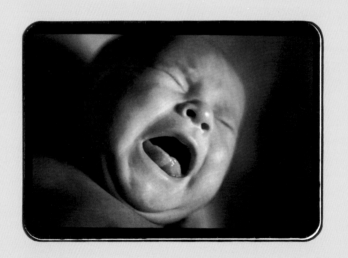

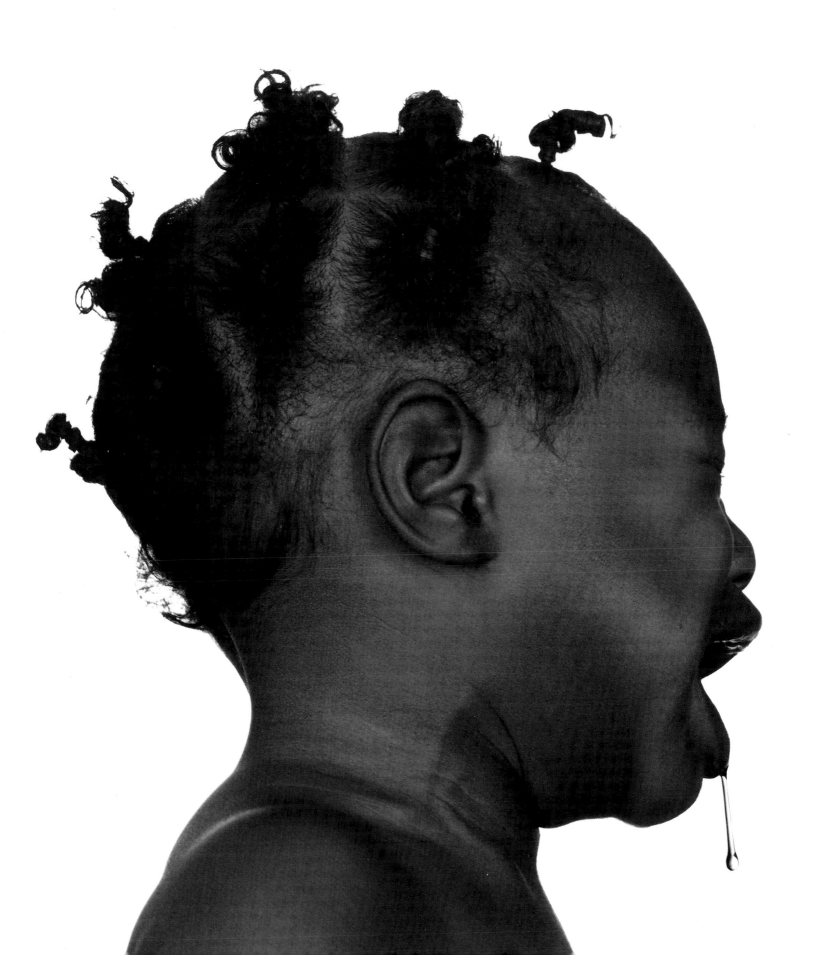

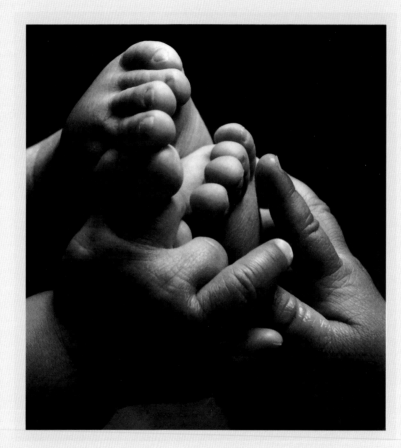

Loving

My best friend made a sweater for my first child before she'd ever had babies of her own. I keep it in

the drawer next to my bed, its matching hat alongside. It is a

perfectly exquisite thing, butter-yellow with an intricate,

almost lacy pattern and little buttons shaped like ducks

marching up its front on webbed feet; the matching hat fits in

the palm of my hand. It almost moves me to tears whenever

I look at these tiny things, so perfect, so pristine. Neither has

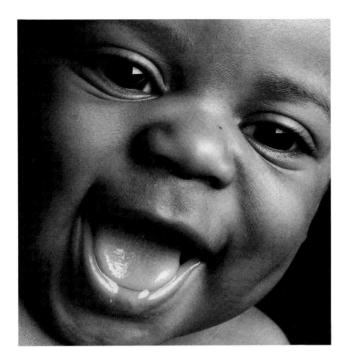

ever been worn. None of my children was even dimly small enough to fit inside their woolly perfection.

❧ That sweater, that hat, represent an idea of baby. The babies I had did not conform to the smallness of that ideal, the miniature human with fingers like daisy petals and a perfect rounded head the size of a grapefruit. My first baby instead had a conehead that took weeks to even itself out after being squished and squeezed during birth. But he had an extravagant head of chestnut curls to cover it. His brother, on the other hand, was bald in that way only babies are bald, a lick of fuzz and then all forehead and goggle eyes. With the third the hair had returned, and with its inky blackness and

tight frizz a kind of maroonish cast of skin. None of them looked much like the idea of baby, the ideal of baby, the Gerber baby, the Ivory baby, the baby drawn in watercolors on the front of the christening card. They were beautiful, in that way babies are, and they were funny-looking, in that way no one admits babies sometimes can be. There were times when they looked elderly, times when they looked addled, and certainly times when they looked like Winston Churchill. Especially the bald one. ❧ At some level all babies look like the same baby, with their small features, sloped shoulders, bowed legs, splayed fingers, or tender fists. This is clear in hospital nurseries,

where the staff put little signs on the Isolettes in part so that parents can identify their own children. No one will admit this, of course, since the mythology of

There are the attenuated
limbs of one and the short

fireplug thighs and forearms of another,

the no-necks and the balloon-faces.

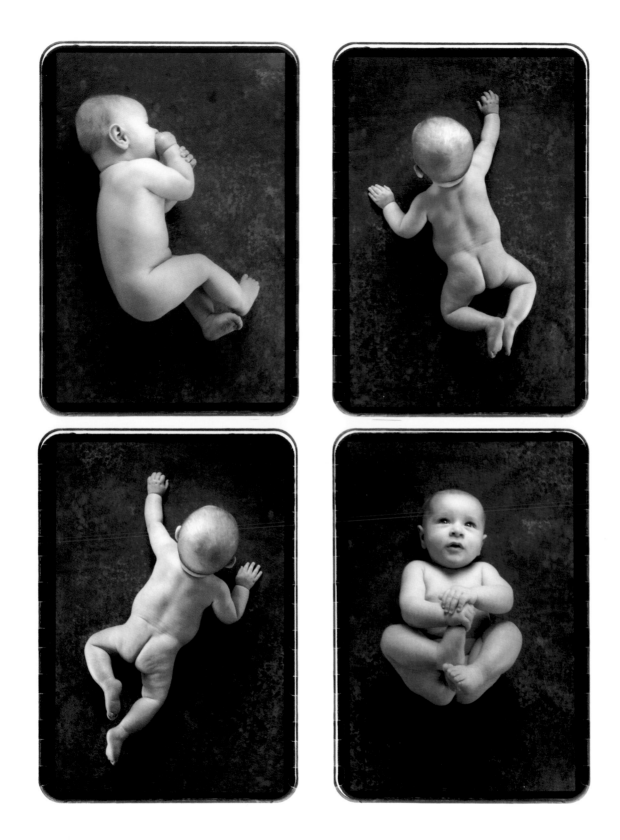

parenthood suggests an instantaneous bond so profound that in a roomful of

wailing infants a mother can discern the cry of her own. All I can say to give

this the lie is to describe the time I stood, weeping, at the sight through the

nursery window of a 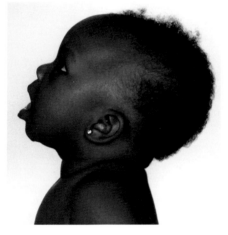 screaming baby just

after the circumcision of our first son.

My doctor patted my shoulder. "I don't

know who that baby belongs to," he said,

"but the one I just circumcised is

sleeping in the back corner of the nursery." ❦ But it's also true that babies

are perfectly distinct, so that it's wondrous sometimes that obstetric nurses

don't just keel over from the sheer variety of human perfection.

The vast panoply of hair alone: the wild tufted thatch

of Asian babies, the bald pink-and-white pate that foreshadows blondness,

the whorl at the crown, like a small tropical storm, and the

fine down that snakes 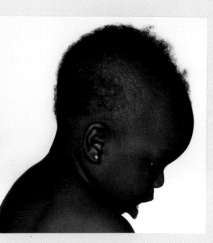 from neck to coccyx.

There are the attenu- ated limbs of one

and the short fireplug thighs and forearms

of another, the no-necks and the

balloon-faces. There are the bottoms,

perhaps the most delectable part of any baby, after the face; my mother had

a theory that you could tell the gender of a newborn baby on its belly

without even turning it over because a boy baby had a triangular butt and

a girl a round one. This went along with her theory that boy cats had pointed faces, girl cats circular ones. As far as I can tell, both theories are accurate.

ß In fact each baby quickly becomes distinct, not only from others of his baby tribe, but from himself in all his different baby stages. The small smushed features sharpen, the limbs unfurl and loosen, the lanugo hair falls out and the early high flush fades, some skin darkens and other skin becomes more pink and pale. The infant is almost a stranger to the toddler. The little curved shrimp of a person rises, shines, develops a straighter back and livelier expression and looks nearly as different from her former self as one baby is from another. ß For one baby is as different from another as a fingerprint or a face.

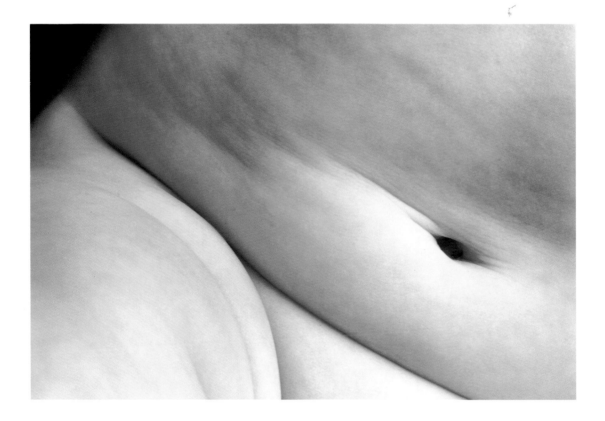

Time goes by, and there is scarcely a memory of another idea of baby

separate from this particular baby person beneath the flowered crib quilt or

slumped sideways in the stroller. On the street or at play group, all other

babies are judged by comparison: too thin or too porky, too frantic or not

alert enough, too pale 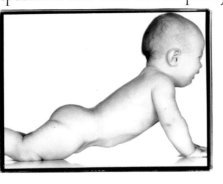 or too dark. And in

short order a trans- formation has taken

place: you still have an idea of baby.

But that idea, that ideal, is your own baby.
Which is exactly right.

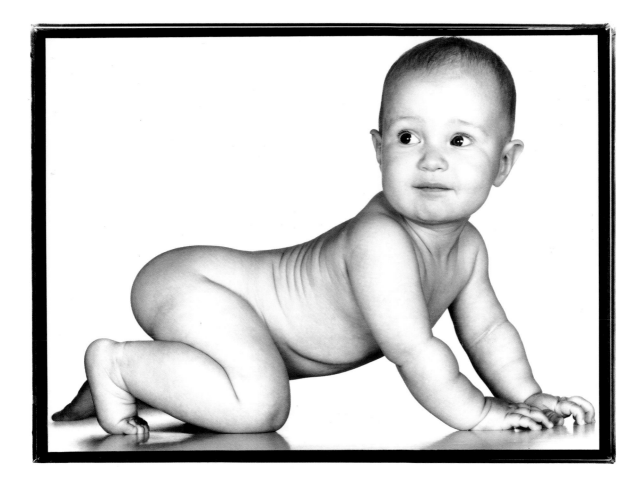

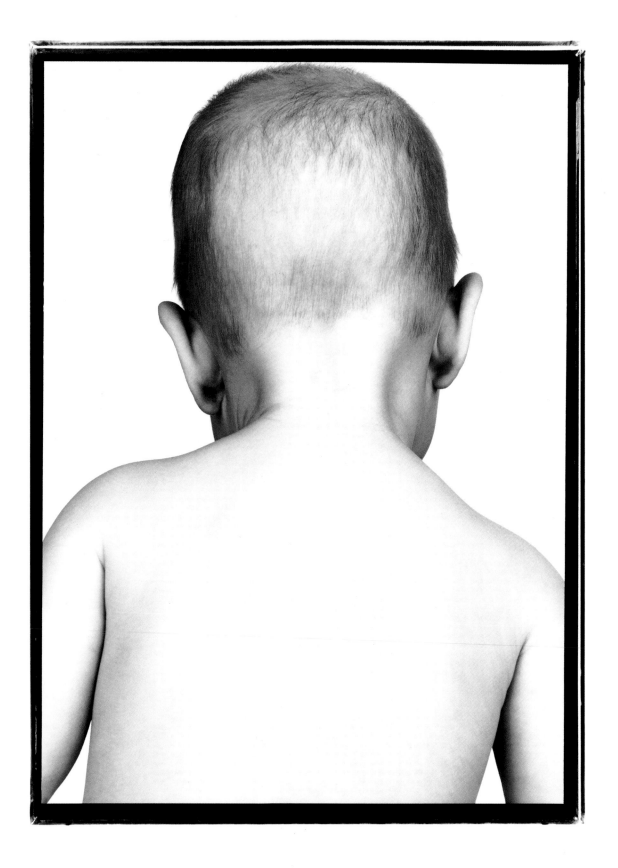

At some level

all babies look like the same baby,

with their small features, sloped shoulders,

bowed legs, splayed fingers, or tender fists.

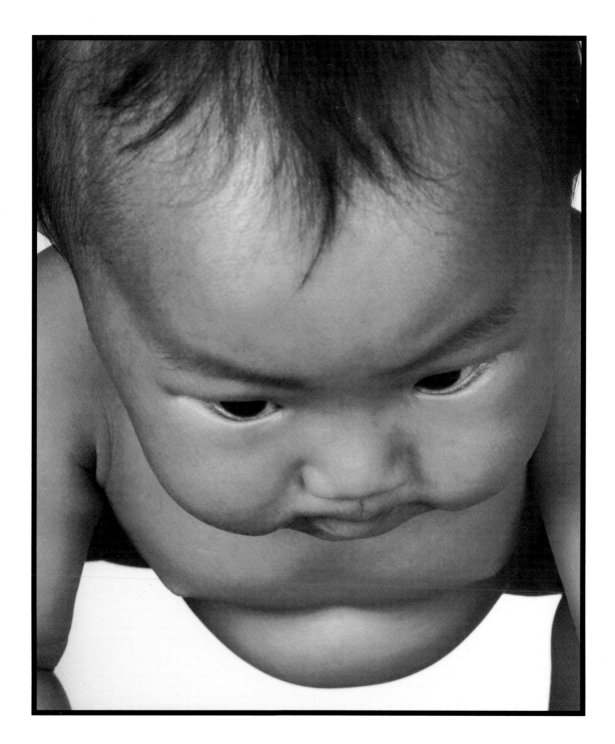

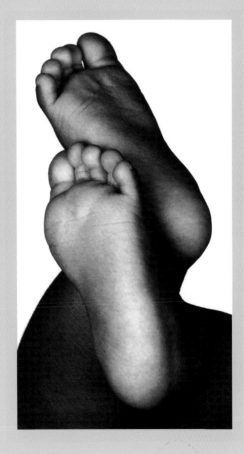

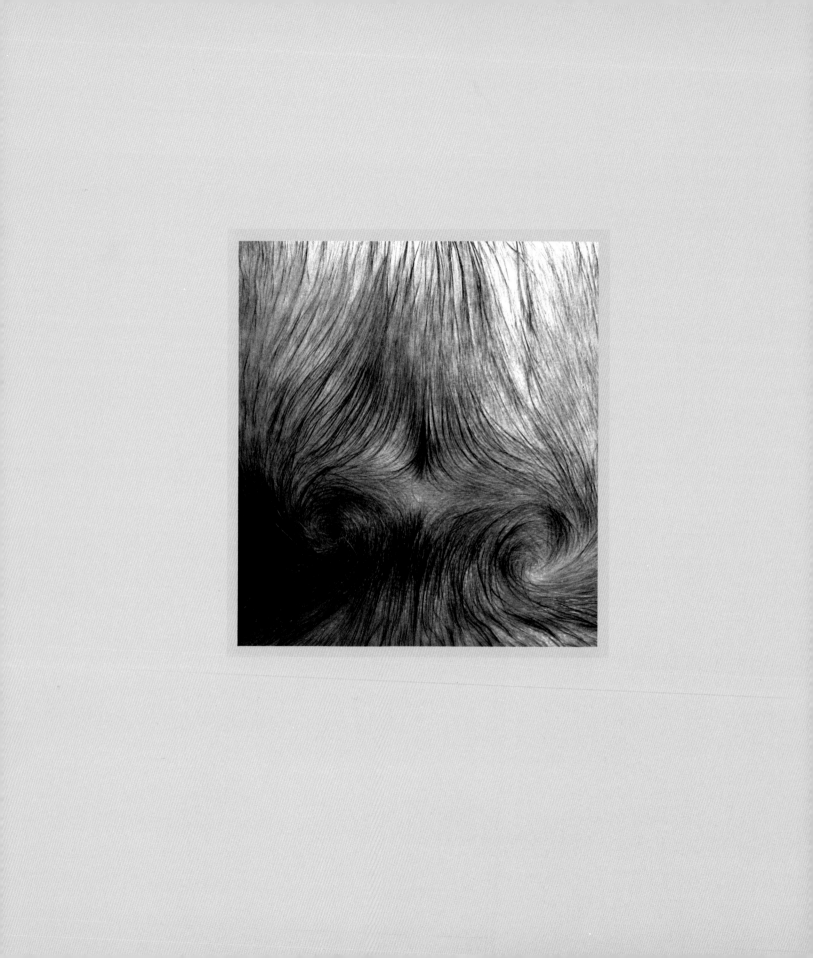

Beginning

 My husband and I have a basic disagreement about the first words spoken by each of our three children. He thinks Quin's first word was "Da." I am certain it was "hot." He thinks Christopher's first word was "Da." I am fairly sure it was "ball." He thinks Maria's first word was "Da." To be honest with you, I can't remember Maria's first word. In my defense let me say that I had three children under the age of five (and a couple of dogs), that it was extremely noisy,

and that I was nearly 40 by that time and prone to fits of short-term

memory loss. I haven't said any of this to Maria, who is today to verbal

acumen what Mary Lou Retton was to backflips in the Olympics.

But I can assure you from considerable study that she will not be pleased.

§ But maybe, just maybe, I was casual about Maria's first word and maniacal

about Quin's (which was, most assuredly, "hot") because by the third
time around I knew something important
about first things. And that was that they
were essentially meaningless.

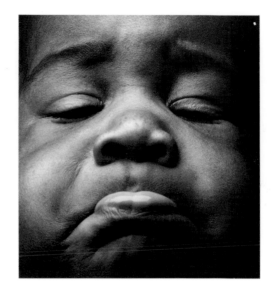

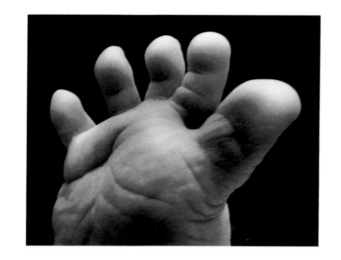

❧ Now, I can feel the muscles around the mouth tightening for those of you out there who have an infant who has recently learned what child psychologists call "reciprocal smiling." For weeks you have been smiling at that sweet baby and talking loving nonsense to her in that high, singsongy voice that we all adopt intuitively for babies. And one day, just as you have finished using the third wipe on a real four-alarm diaper attack, you've looked up and seen her little Parker House roll of a face crease up into a wobbly but undeniable grin. ❧ Time stops. ❧ "Did you smile?" I said the first time my first baby did it, as though to add to the excitement he might just say, "Yep, and now I'm ready for the right breast." ❧ Notice that I remember the occasion. And I sort of remember when Christopher did it. And I am pretty sure that when Maria first smiled she did not smile at me

if your baby's
 only trick is putting

his thumb in his eye, you don't

have to assume that he will never

be an illustrator or a golf pro

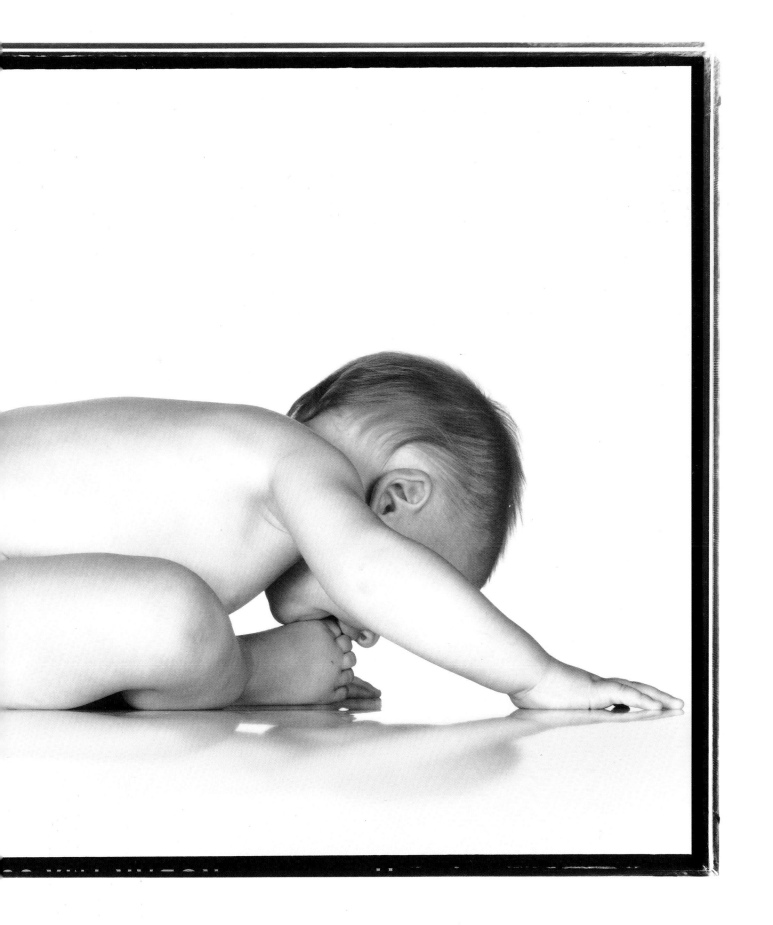

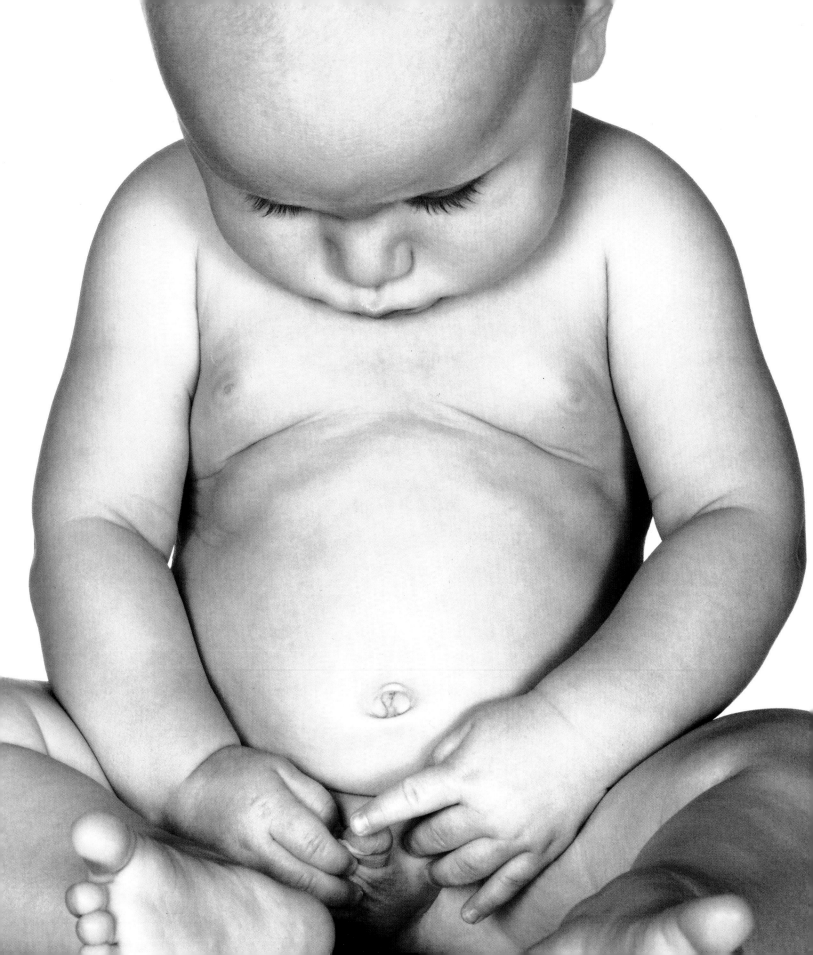

but at one of the boys, because everything she ever did she did for their benefit and not for mine. I mean, her brothers had Lego blocks and a stuffed Snoopy dog to play with, whereas she had two live toddlers with loud voices. No contest in the infant-stimulation sweepstakes. ❧ There is no doubt that these first things are magical, that you hunch over the changing table waiting for another smile, that you shriek, "You rolled over!" as though the next step will be the Nobel or the Presidency, that a first step is like watching the history of human civilization from small fishy things to Neanderthals unravel in one instant before your eyes. But we invest first things not with too much moment, but with too much meaning. A baby who smiles early will not necessarily be the happiest child in second grade. The early walker will likely not be a gymnast. ❧ When a baby sits on the floor and pushes a ball back and forth while his dad crows, "Good arm!" we are in fact witnessing the dawn of something. That something is called projection, and we all do it to our children. The trick is to keep it under control at all times.

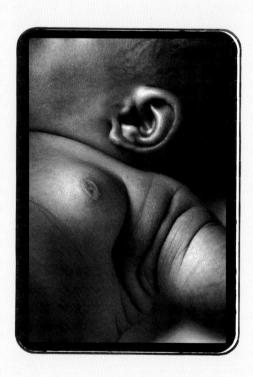

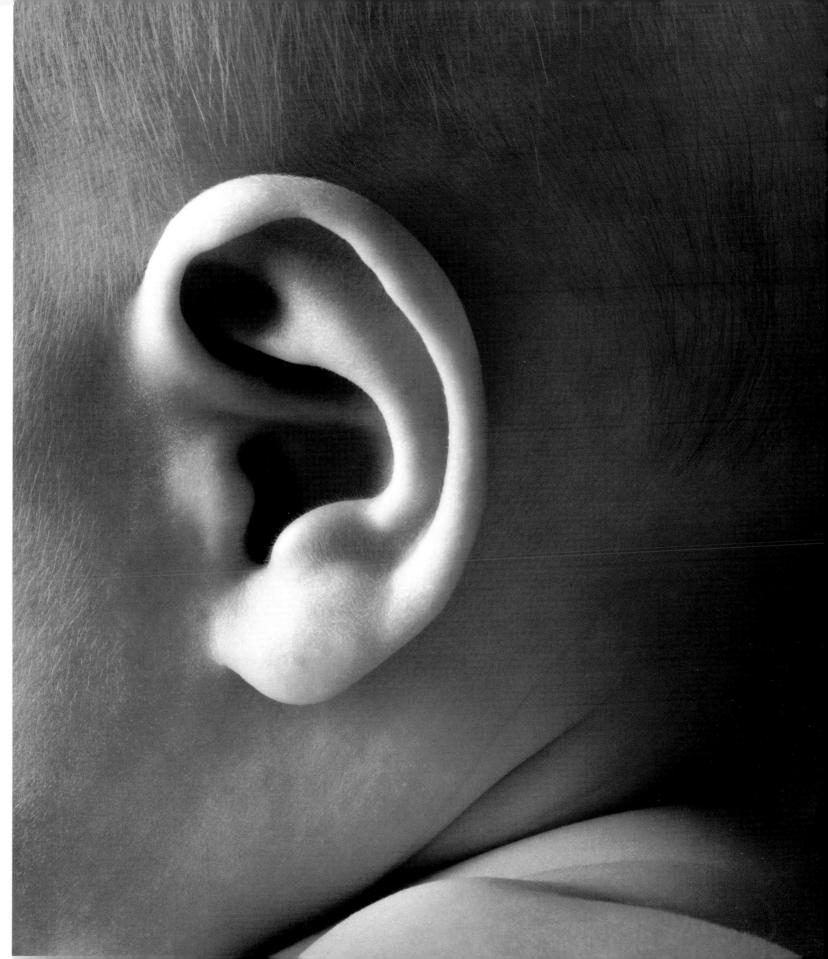

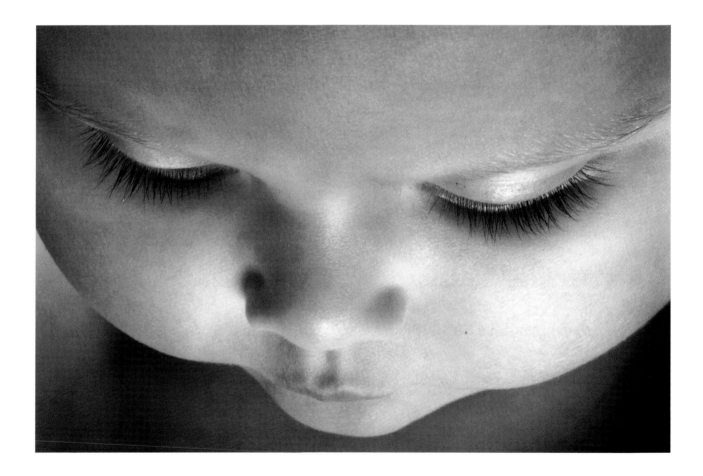

you come to school for writing workshop tomorrow, because I'm going to

be in the author's chair and read my new book that I wrote?" And I

think that first things are a little like weddings, beautiful and memorable and brand-new and moving and heart-stopping. But it's the marriage that really counts. ❧ Ah, heck, let's just agree

that her first word was "Da."

a first step is like watching the history of human civilization

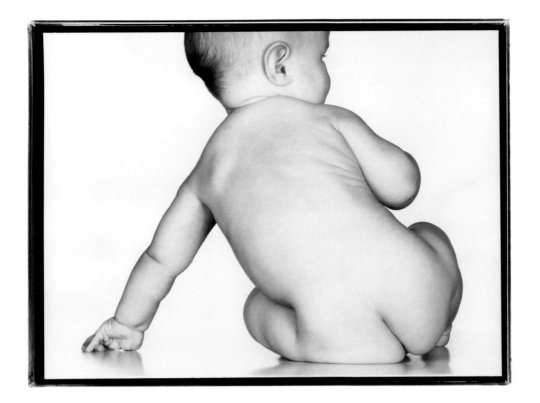

from small fishy things to Neanderthals unravel in

one instant before your eyes

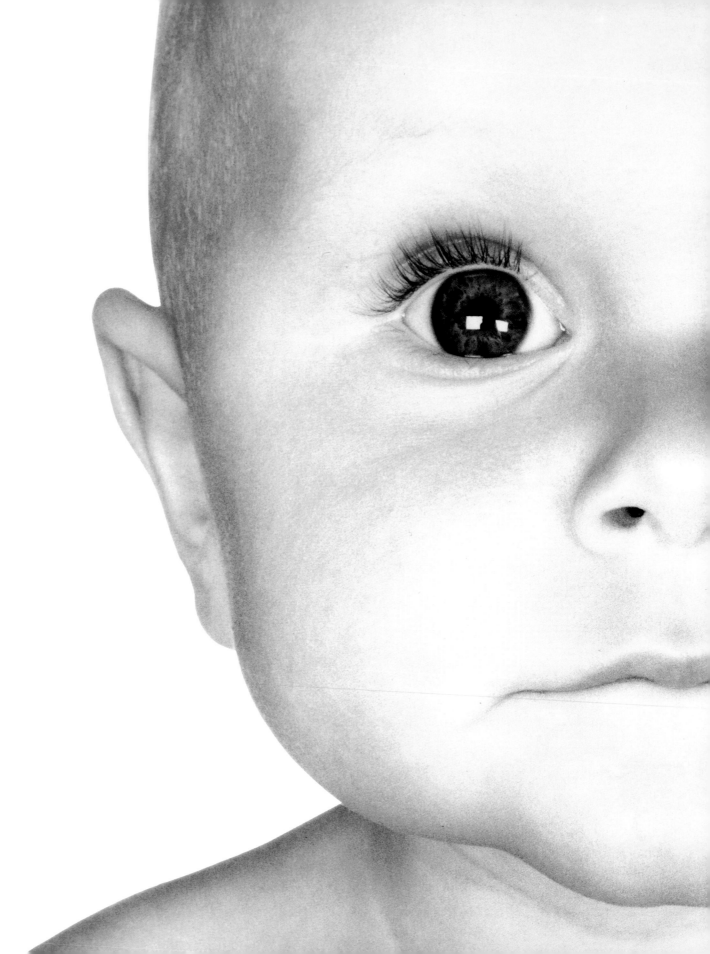

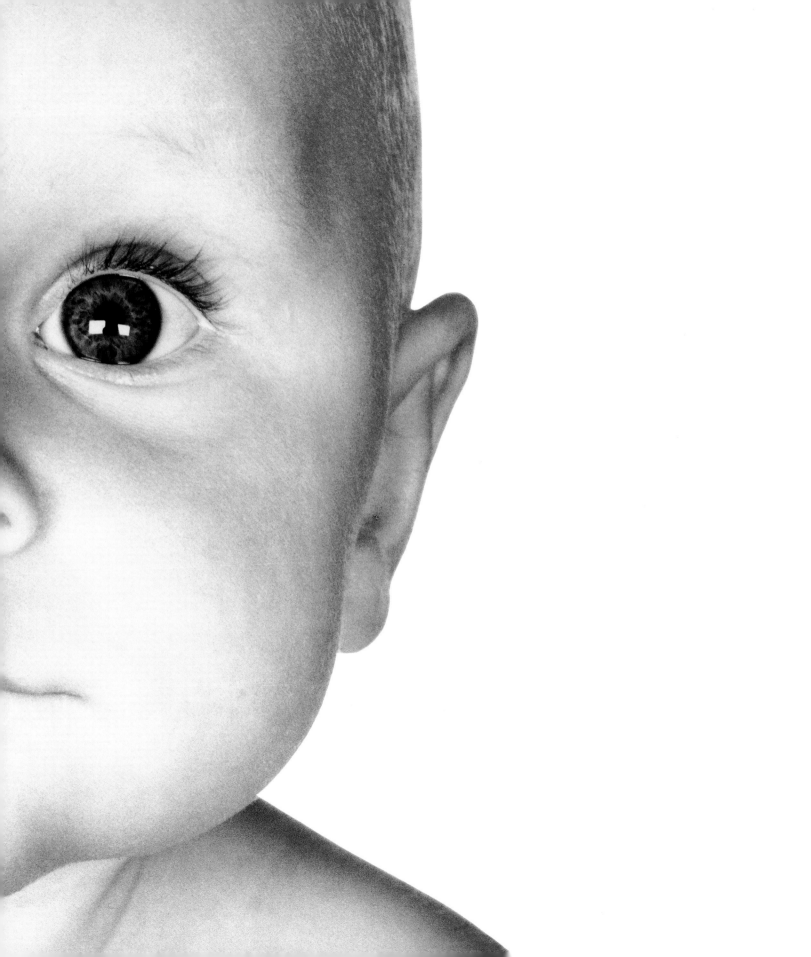

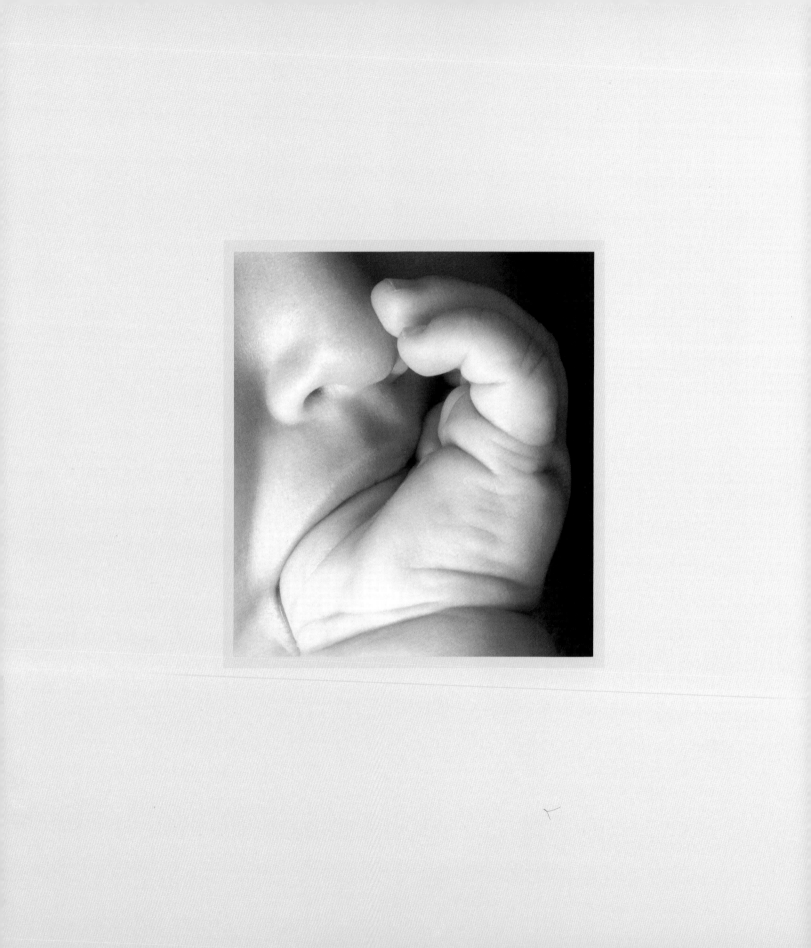

Growing

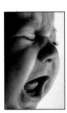The only way I managed to get through childbirth, which I distinctly remember as the most magical, transformative, hideous event of my life, was to put myself in the baby's place. Oh, I was in agony, despite all the books I had that described labor as discomfort, but as I was rolling around hating the flowered wallpaper and the old oak rocker in the birthing room, I managed to focus from time to time on what the other half of the equation was going through:

one moment floating in warm salty water, half-asleep in the dark, the next

being shoved headfirst down a narrow chute toward a punishing bright light.

Like dozing on a beach in the Caribbean only to wake suddenly in the

Lincoln Tunnel at rush hour in a convertible. No wonder their first sound is

so often a wail. ❧ From time to time I would lie on

the floor with my babies to see exactly what

they were seeing when it looked as though they

were just wasting time. And on the street I would squat down

so that I could see what the passing parade looked like from a two-year-old's

perspective, and I can tell you, it's scary and big down there. This, I've

concluded, is the key to being a halfway decent parent all the way through

the process: putting yourself in the baby's place. It works just as well with

adolescents, although it's considerably more terrifying. § The interesting

thing is that so few grown-ups do this. All of them have been babies at one

time or another. (Many of them, in the very worst sense of the word, still

are.) But instead of empathy, they take the road of condescension; a good

baby should be a 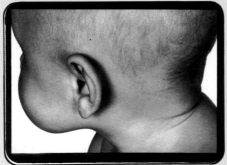 baby that acts like

an adult as soon as humanly possible.

§ The peculiarity of this is underscored

not only by the pleasure babies clearly take in being babies, but in the plea-

sure anyone with half an ounce of sense would take in it as well. The spon-

taneity of expression, the constant self-discovery, the intuitive comfort they

manage to find in elusive smells and sounds: being a baby is a

good gig if people would just leave you alone.

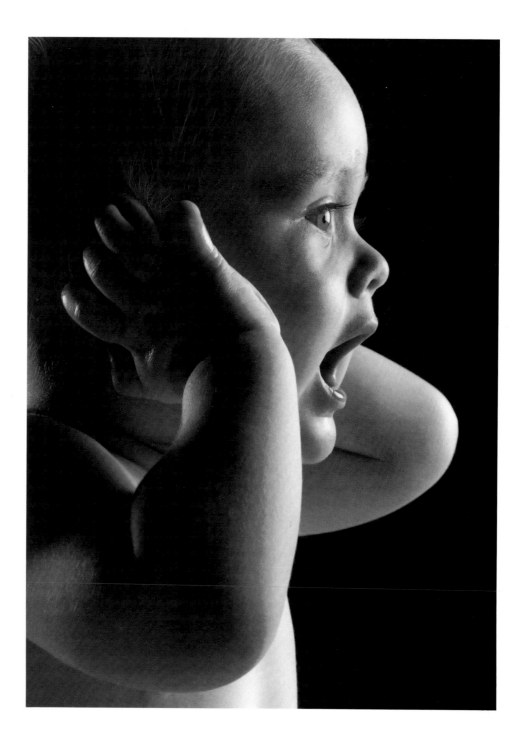

And they do, for about six weeks, before they start saying you're a big girl

now and should, by gradations, begin: ◆ sleeping longer

◆ crying less

◆ eating differently

◆ getting around more

That attitude reminds me of one evening—and in my own defense I must

say that it was during the arsenic hours between dinner and bedtime—

when I accused my six-year-old of behaving

childishly. ◈ "I *am* a child," he said plaintively. ◈ There is only

one possible explanation for this attitude, and it is that adults are

jealous of children. The reason why is obvious: being an adult is not all it

is cracked up to be. All the behaviors that babies perform with ease and

aplomb are either stifled or perverted when we are older. A baby cries extrav-

agantly, paying homage to the pain or hunger or whatever ails him; he does

not attempt to stifle his tears with a tissue or to apologize for what he feels. A baby explores her own body with curiosity and joy; it will be years before she begins to understand that the world considers some parts of her beautiful self too shameful to touch, to display, to even mention. A baby does not clothe his personality in the sweaters of subterfuge, is never blasé. When a baby notices something new, he *notices.* One of the scariest things in the world is a depressed baby; the affect is completely at odds with the source. ❧ It is no wonder, then, that while we grown-ups sometimes push our babies into the great beyond of maturity, we also try to find our own way back to what we have lost. It is no great revelation that cigarettes, beer, and Sara Lee chocolate layer cakes in quantity are simply substitutes for a well-placed thumb or nipple, that most beauty routines are designed to return to the skin the

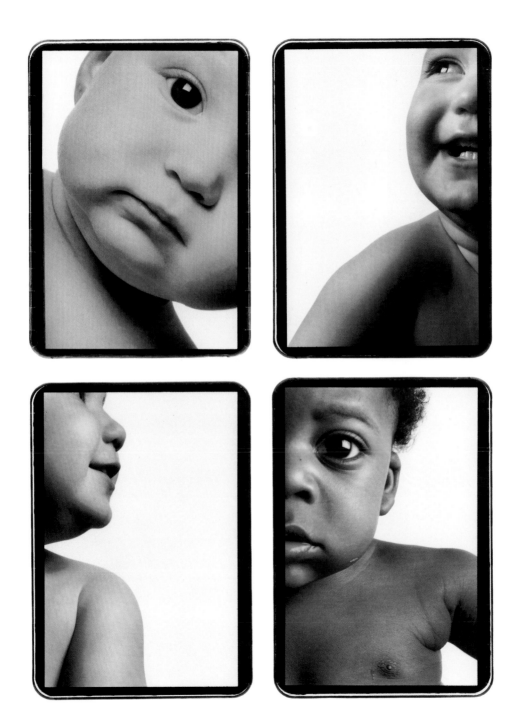

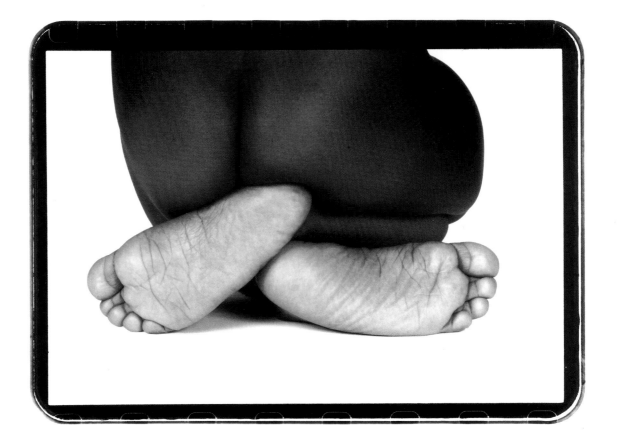

every day we move

 further from babyhood

 is a small forgetting

softness and luster it had when its wearer was six months old, and that it

feels much better, faced with pain or fear, to simply open up and scream.

The next time you are sitting in a meeting after three cups of coffee, badly

needing to go to the bathroom but instead doodling dutifully, crossing your

legs and watching the clock, remember that if you were a baby you would

have gone by now, and no one the wiser. ❦ While maturation is most often

presented in books as a process that enables us to learn what we need to

apprehend and manage the world, there is clearly an opposite corollary, and

that is that every day we move further from babyhood is a small forgetting,

an intuitive if not cognitive loss of an ability to be comforted, behave, simply

be without self-consciousness or guile. What happens instead

is that we are civilized, which is the opposite

of babyfied. There are certainly advantages to the process, as anyone

A baby cries
extravagantly,
paying homage
to the pain
or hunger or
whatever ails him

Leaving

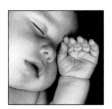The strangest thing about having babies is that before you know it you have adults. You would

have thought you'd figure that out, but the truth is that for a

long time you don't. It sneaks up on you in increments, bit

by bit. At the second-birthday party you sit and rhapsodize

about how much he's grown. At the barber's you watch baby

hair fall to the floor. On the first day of preschool you weep

at the sudden silence in the house, then take a long, hot bath.

§ But a second-birthday party, or a first haircut, or that bright beautiful terrible day when you peel him off you at preschool are one thing, and waking up one morning, going down to make coffee, and finding yourself vying for position at the sink with someone whose eyes look levelly into your own and whose feet are bigger than yours is quite another. "Hey, Ma," he says. "What's up?" And because the light comes through the window at a certain angle, and because you're looking for it, you can see the faintest shadow of what used to be down

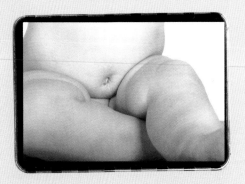

on his cheek, down so fine that it once felt like silk when you ran your lips across it. Before the coffee is done, before the sun rises to half-mast, before you've turned away so he cannot see your face, that down will be a beard, and he will be a man. ❧ This baby lay inert over my shoulder once, so akin to a pillow with half the feathers floated out that he was nicknamed Mr. Limp. He sucked on my little finger in the car, duped into believing it was a nipple. I have photographs of him I took, self-consciously, to preserve him in his exquisite nakedness.

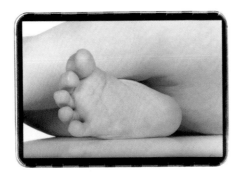

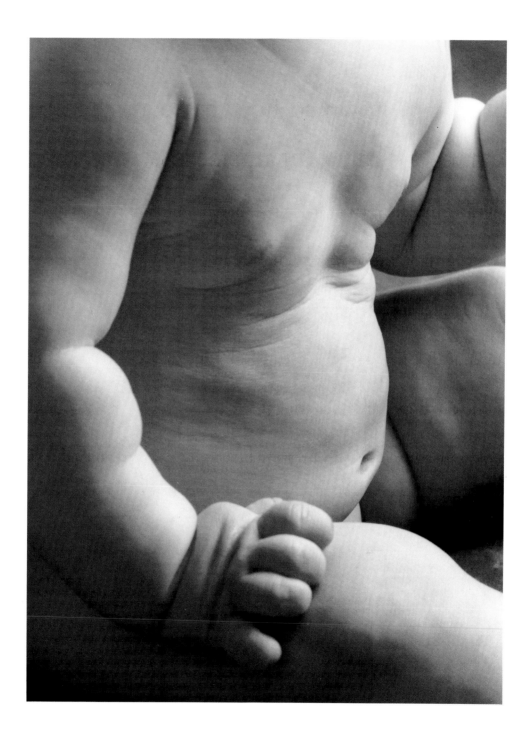

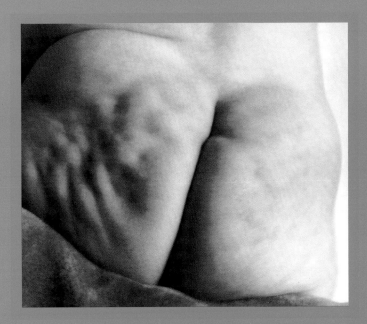

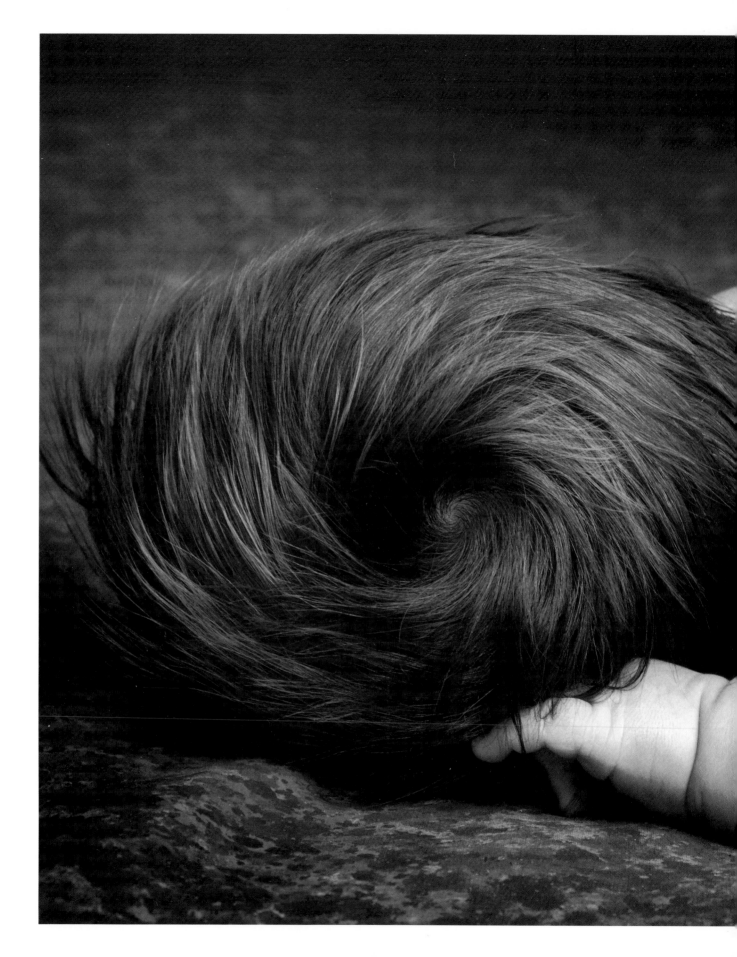

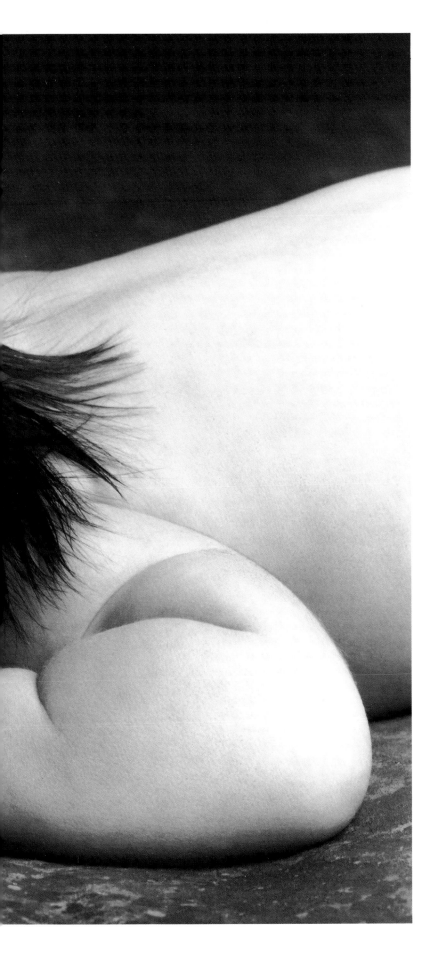

The
strangest
thing about
having
babies is that

before you know

it you have adults.

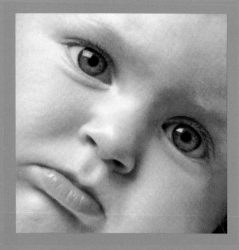

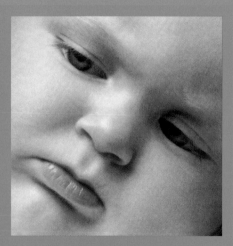

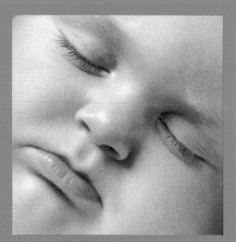

Others bronze shoes; I would have, if I'd thought of it, taken a cast of his

tiny feet, with their little lentil toes and arches the parabola of perfection.

❦ Ah, this baby was sort of perfect, in that way that first children often are,

since we have no point of comparison and find their every burp and poop a

miracle of nature. He slept early, ate mightily, amused himself for whole stretches of minutes poking himself in the face with his fingers.

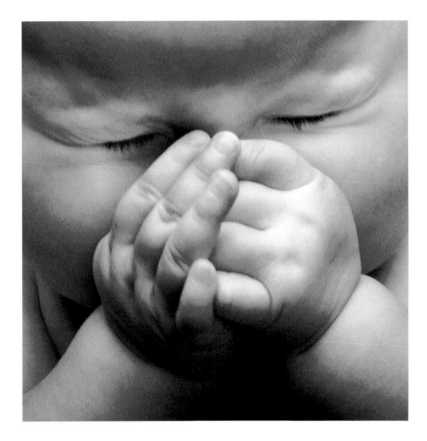

Ah, this baby was sort of perfect,

in that way that first children often are, since we

have no point of comparison and find their every

burp and poop a miracle of nature.

He had a great throaty chuckle, as though somehow he had developed a sense of humor before he'd even acquired language. We could put him down on a blanket and forget about him while he cruised the internal baby Internet of sensation, sound, and sight, his eyes alternately wide and dreamy. ❦ And as he grew he seemed to have only one drawback: he did not move. It would be too strong to say that he was an inanimate object, his eyes so bright and his mouth so curly. But certainly there were times when we could have considered using him as a doorstop. ❦ As the children around him hoisted themselves laboriously to their hands and knees, as they pulled themselves up on coffee table and dog's back, as the more wiry and dissatisfied tottered from one place to another pulling down books from the shelves and banging into furniture, he lay on the rug, occasionally rolling over or, on a particularly ambitious day, maneuvering into a sitting position

from which he would plant his palms between the deep V of his chubby legs

and survey his universe, his kingdom. But his first birthday came, and went,

and his second lay close on the horizon, and he went to a toddler group

three mornings a week and sat, smiling, as the others eddied around him,

their feet, now shod, their legs, now slimmer. ❧ Strangers suggested that I

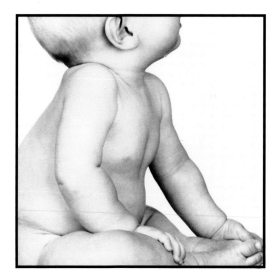

might consult a neurologist. Old people said that I was babying the boy, should lift him out of that damn stroller and plant him on the pavement. Grandparents silently worried about the forceps delivery. And one mother said sweetly, "Oh, he's probably just slow." ❧ Where is her daughter now, who walked at 10 months and used to stumble over my beautiful placid sedentarian as though he were a Big Wheel in the middle of the playroom floor? I neither know nor care. It seems so long ago now, all of it, when I watch him hustle down the basketball court or hear the sound of his key in the lock after he has taken the train home alone from school. Shambling, ambling, loping, he describes the path from refrigerator to desk to television to bedroom to stereo to computer, and as he passes me by—me, who once worried so whether he would ever, ever walk—I want to throw the lariat of my love and my arms around him and say: Stay still.

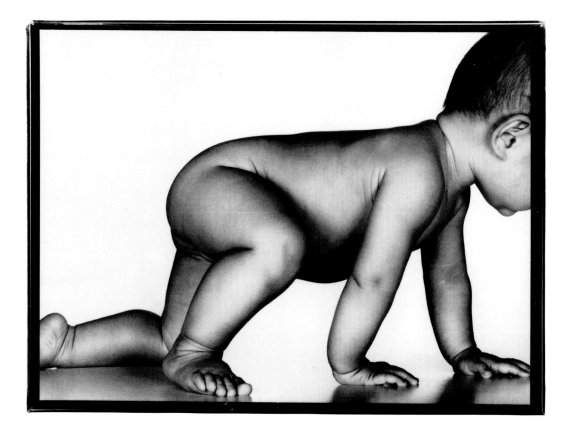

I want to throw the lariat
of my love and
my arms around him and say:

Stay still.

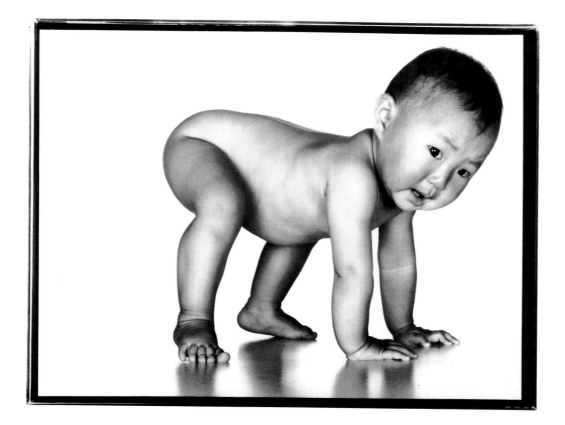

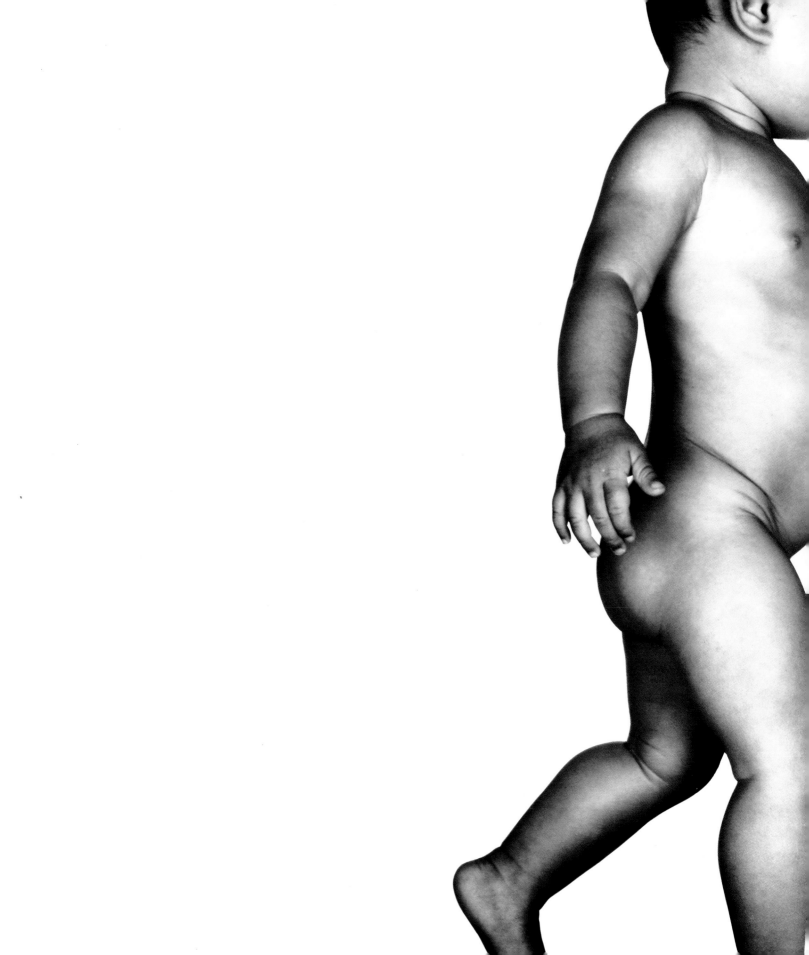

ACKNOWLEDGMENTS

The thanks I owe are numerous and heartfelt. ❧ First to Anna Quindlen for listening and looking and saying yes. She instinctively knew what this was all about. Anna, the love I have for my family has grown through your writing. I can't think of a higher compliment. This has been such a privilege. ❧ Elizabeth Williams has given me her knowledge, her friendship, infinite patience, and a baby, Cotten. The support of my wife and son is what keeps me alive. I love you both. These photographs are really about what we've made together. And, I might add, it was Liz's idea to call Anna. ❧ David Cohen acted as my agent on this project. He has always been there to share generously his enormous talent and insights. His friendship has actually rerouted my life. David is the very best. Thank you. ❧ From the start I kept pinching myself, wondering how I was lucky enough to end up at Penguin Studio. The level of professionalism and taste shown by our publisher, Michael Fragnito, our editor, Marie Timell, and our production manager, Alix MacGowan, together with the courtesy they showed Anna and me was a dream come true. Thank you. Thank you. ❧ To my colleagues at Kelsh Wilson Design—Matthew Bartholomew, Mike Butler, Lia Calhoun, Cindy James, Vicky Lee, Lisa Winward, and Kathie Wissmann, and my loyal partner, Fred Wilson—I have these thoughts: your excitement for the babies was a constant source of inspiration and your patience with me a blessing. And Lisa and Lia, the design is perfect. Thank you. ❧ So many friends have contributed their knowledge and enthusiasm: Sherry Baskin, Leslie Bennetts, David Boldt, Linda Figliola, Chet Gebert, Tom Judd, Jain Lemos, Bill Marr, Angus McDougall, Dave Moser, Gerald Richardson, Gayle Sims, Nancy Steele, Mark Strand, Bonnie Timmons, Carolyn White, and Jan Winburn. I'm indebted to you all. ❧ A special thanks to Bob Martin. I think you're some kind of genius. ❧ And finally, and I think most importantly, my profound gratitude to my friend and assistant, Kevin Monko. He was there for each photograph. His ideas are everywhere in this book—not to mention his own naked baby, Olivia. ❧ There is only one regret—that the child Liz and I hope to adopt this year hasn't arrived in time to be pictured in the book. That was always a silly fantasy I had. ❧ Not to worry, Sweetie. When you finally find us there will be another book. A lifetime of photographs lie ahead. —*Nick Kelsh*

When Nick Kelsh called and introduced himself, I had neither the time nor the inclination to work on any projects but my own. Then I saw his photographs. He has my deepest gratitude for letting me put words to the extraordinary music of his images. My thanks, too, to Quin, Christopher, and Maria Krovatin, who are responsible for all my best material. Everything I know about naked babies I learned from them. —*Anna Quindlen*

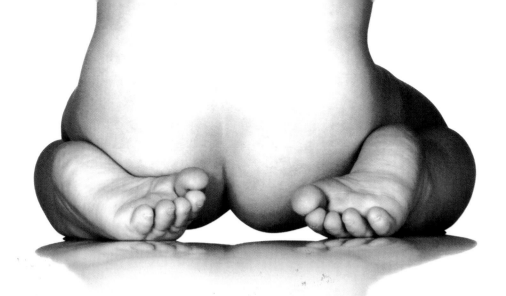

For the babies: *I hope you are always as proud to find yourself on the pages of this book as I was to have put you here. The love your parents have for you was evident every time one of you came into the studio. To your parents I say this: For your good humor and willingness to share your beautiful children, I will always be profoundly grateful.*

Without exception, it was pure joy to photograph every one of the following babies.

Elias G. Bartholomew, son of Laura Silverman and Matthew Bartholomew *Eden Beschen, daughter of Kate Beschen and Mark Rubin* Elliot Marcus Bullen, son of Bridget and Mark Bullen *James Davis Carino, son of Anne and Jim Carino* Gregory Sean Chabolla, son of Michelle and Jesse Chabolla *Anna Alicia Gabrielle Clarke, daughter of Rita and Alberto Clarke* Aaron Benjamin Cohen, son of Colleen Puckett and Jacob Cohen *Mia Qian Miller Collins, daughter of Huntly Collins and Esther R. Miller* Ashli Victoria Cooper, daughter of Carla and Charles Cooper *Caitlin Harms Del Roccili, daughter of Monica and John Del Roccili* Mbenoye Deborah Diagne, daughter of Sabrina and Mody Diagne *Paul E. Hochschwender, Jr., son of Stacy and Paul Hochschwender* Khashae Eschelle Jackson, daughter of Eschelle D. and William A. Jackson, Jr. *Devon Hill Kelly, daughter of Laura and John Kelly* Marquan LaShawn Lundy, son of Regina A. Price *Jacob Macneal, son of Alina and Christopher Macneal* Caleb Morgan Madder, son of Susan and David Madder *Keith Richard McHugh, son of Angela and Dennis McHugh* Galen Rebecca McMullen, daughter of Julia and Paul McMullen *Olivia K. Monko, daughter of Linda Figliola and Kevin Monko* Christian Cosmo Pagano, son of Sharren Dadswell-Pagano and Cosmo Pagano *Anthony John Passante-Contaldi, son of Catherine Passante and Edward Contaldi* Kaya Peterman, daughter of Joanne Donahue and Timothy Peterman *Sean Robert Sauder, son of Cheryl Decker-Sauder and R. Barry Sauder* Andre Malik Simmons, son of Denise Darcel Dixon and Leroy Simmons *Mimi Rand Simpson, daughter of Johanna Crawford and Christopher Simpson* Sylvia Janet Strauss, daughter of Susan Warner and Robert Strauss *Harrison Watts Tracy, son of Karen and Ernie Tracy* Geoffrey Nathan Baxter Trotter, son of Timika and Joel C. Trotter *Neil Vermani, son of Maya and Pawan Vermani* Perry von Stade, son of Caroline L. von Stade *Skylar Rae Walter, son of Robin and Fred Walter* Sophia Weinrott, daughter of Lori and Jon Weinrott *Graham Wright, son of Deirdre and Rick Wright*

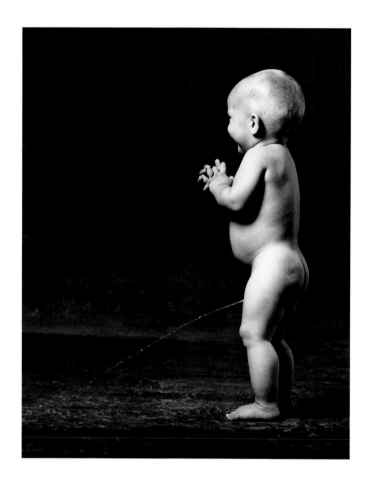